MW00563918

A LYRICAL COLOURING BOOK
SPIRIT
of the Wild
artwork by **ERICA NEUMANN** poetry by **DAWN SPRUNG**

Victoria • Vancouver • Calgary

COLOURING THE WILD

The colouring panels in this book are based on oil paintings. Although they can be coloured any way you like, creating a more realistic, three-dimensional effect involves working with "value"—the lightness or darkness of a colour. On each page facing the colouring panel, you will find a black-and-white image of the original painting. Intended as a guide, this image will let you know where the darker colours are. These darker areas have been outlined in a heavier line on the colouring panel. Any colour can be used in the darker areas, as long as it is dark.

Opposite is a value scale, where you can check how light or dark your colours are. Scribble a little bit of colour next to the scale where you think it matches the darkness. It is easiest to start with dark blue or black. Squint your eyes and make your vision a bit blurry, then look at your colour and the dark square next to it, quickly, back and forth. When the values match, they appear to melt together. For example, it is obvious that a dark blue or purple does not belong at the lighter end, as there would be too much contrast. Written above the scale are the colours that usually fit in those areas, but feel free to use your own colours to see where they belong.

To achieve dramatic eyes in the animals, the pupils are usually the darkest colour there is—black, if possible. Colouring this first will reveal the iris, usually represented by a brown half-moon shape. Finally, the irregular dots on the eyes are reflected light from the environment around the animal, and could be coloured last. Blues work quite well.

Feel free to follow these guidelines as closely as you like, or use your imagination and let the wildness spirit you away . . .

dark blues, browns, purple, dark green, black

reds, oranges, pinks, light green, light blue

yellows, peaches

CINNAMON BEAR

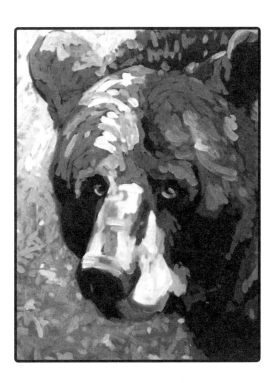

His keen scent
That was what gave him warning,
And using his sharp curved claws,
 he could have clambered up the tree with ease . . .
But instead,
 his paws pounded heavily onto the forest floor
 as the ground and onlooking creatures trembled.

Then he stood
 . . . colossal
And gave a deep growl.

Some time after the stillness
He wandered away,
Long into the forest
Seeking his solitude
Content, having inspired those
 who needed courage.

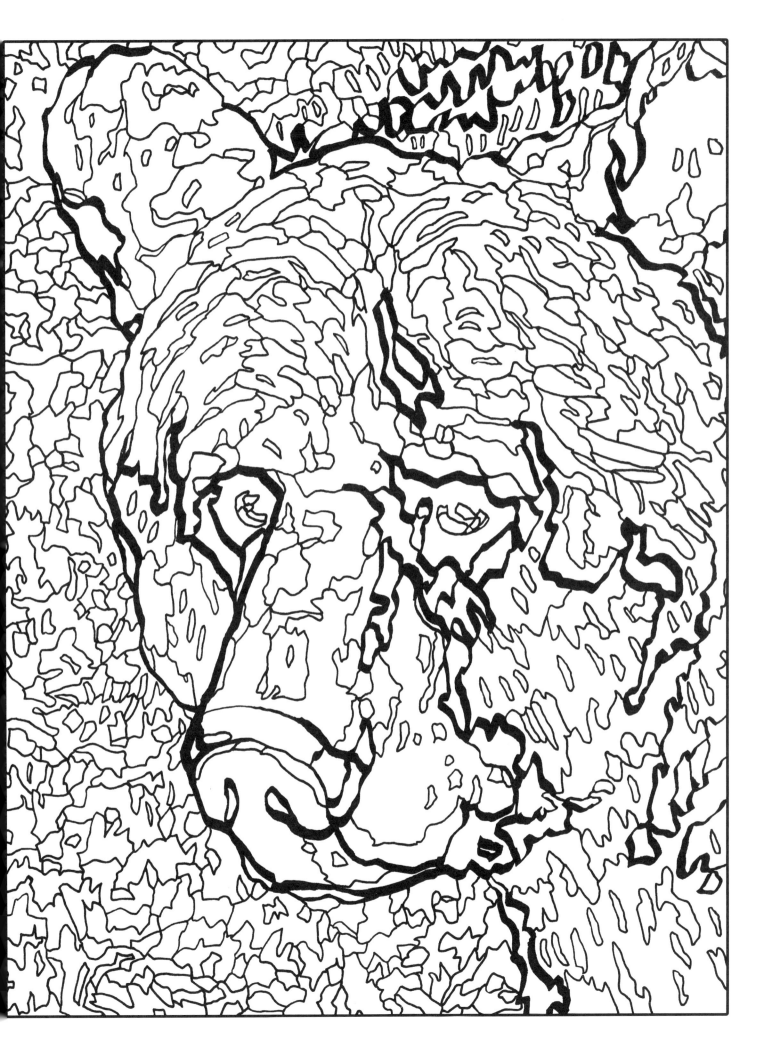

SKUNK

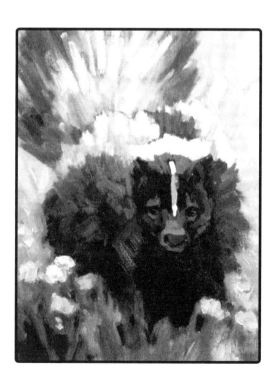

Her long curved claws
 scratched at the entrance to the hive.
Angry bees emerged,
Then she caught them in her mouth.

Her kits looked on
And she clawed, and clawed again.
Bees boiled out;
The skunks consumed thousands,
Their thick fur protecting them from the stings.

Calmly and assuredly, she led her kits back home.
Still, she was wary of the creatures of the night.

A fox nearby . . .
The skunk hissed, stomped her front paws,
 then lifted her tail high.
The canine quickly scampered away.

Now, almost at her burrow,
 she spotted the owl.
They were in grave danger!
She immediately lifted her tail and sprayed.
But with its poor sense of smell,
 the owl was not deterred.

At once, they scurried through the nearest
 entrance to their burrow.
It was a narrow escape . . .

The great horned owl waited patiently
 on a branch above them
But the family of skunks were well fed
And nestled in for a long sleep.

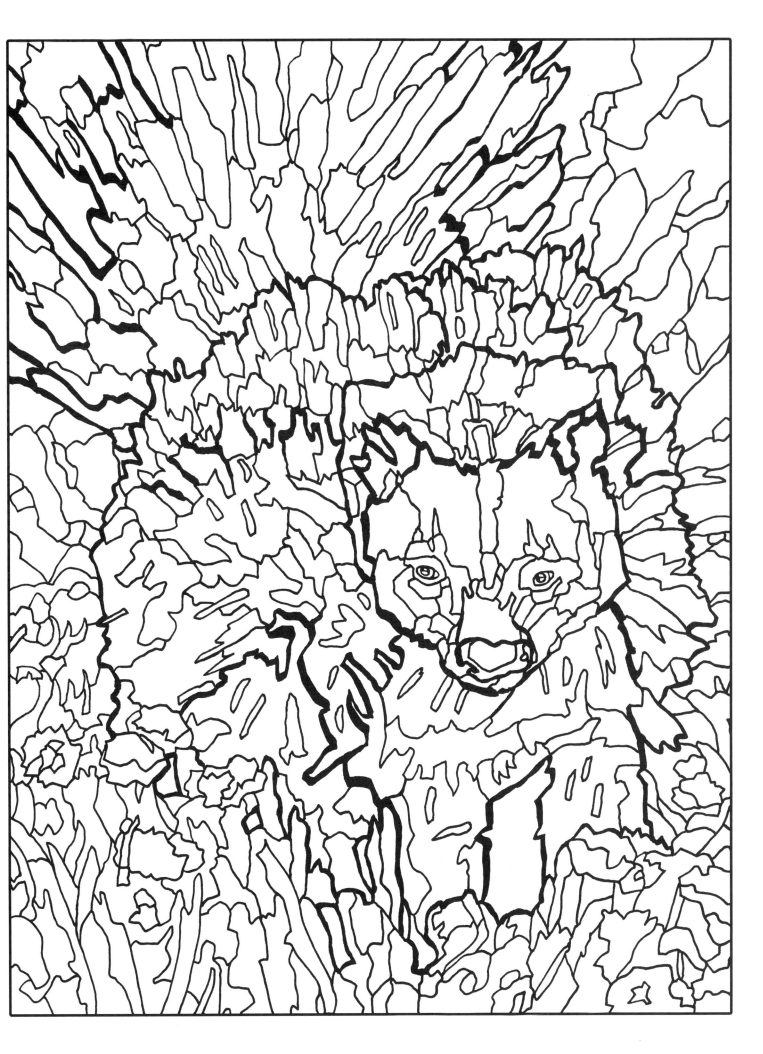

P O R C U P I N E

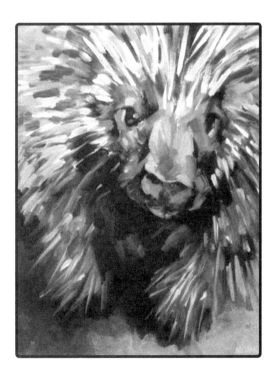

A woodpecker hammered into the tree
And awoke the porcupine
That had been sleeping on a wide branch
below.

The critter scampered down the tree,
Seeking out clover at the edge of the forest.

He sensed an intruder
And quickly ran away,
Climbing a tree with ease,
And watched from above
 . . . a coyote scurried through the bush.

Later, while the peaceful creature gnawed on bark,
 he smelled another predator, approaching
 from behind.
He turned his back to it and hissed,
Growled . . . feet stamping.

But the fisher simply jumped over him.
Again face to face with the porcupine,
It clawed at his eyes.

The porcupine's cry was shrill;
He turned once more, fast.
But the fisher leapt over him again,
Still attacking his face.

Now the porcupine was confused,
 and afraid.
He turned
And this time
 ran backwards
 ramming the attacker.

And just as the fisher was to leap again,
Barbed quills were shot and imbedded into its face,
Which began to swell instantly.

As the fisher screeched in pain,
 the porcupine disappeared through a rock pile.

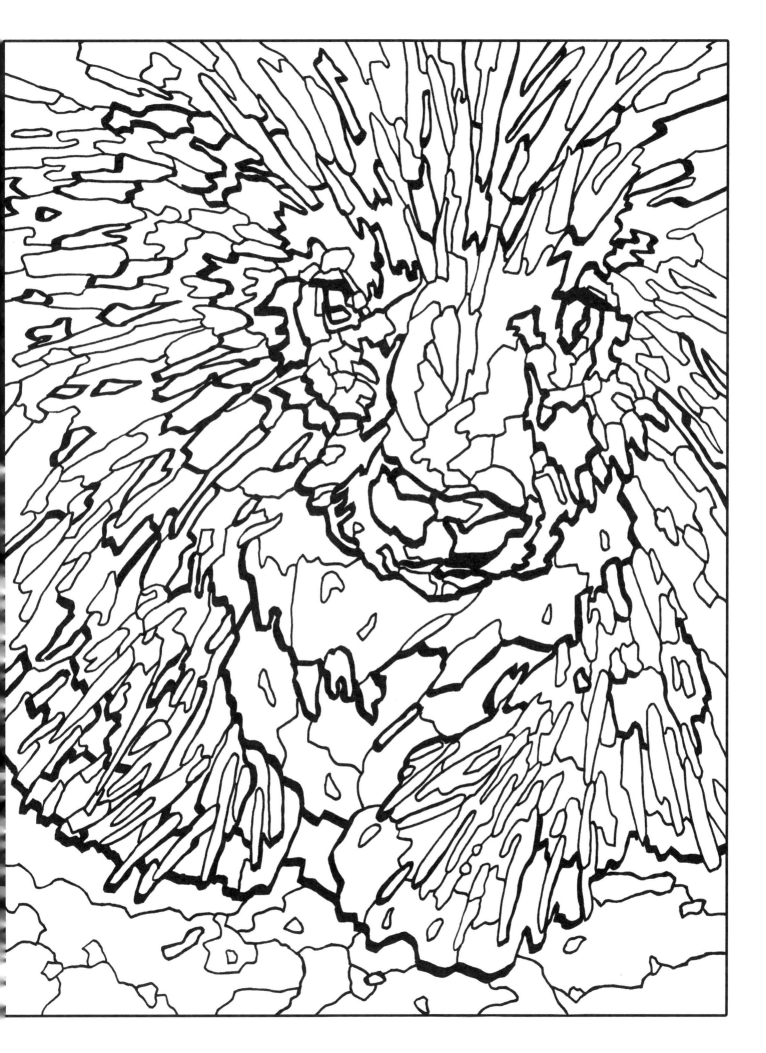

M O O S E

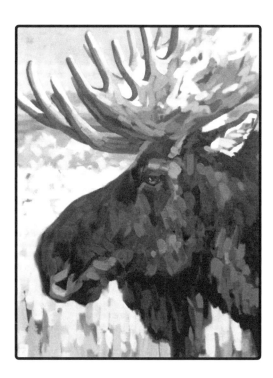

As tall and gangly as the moose was,
 he moved silently and gracefully through
 the forest.
He stopped to feed on the sweet white birch
And stood on his hind legs to reach
 the top branches.

He got down on his knees,
 to nibble on the new growth that emerged from
 the forest floor.

But he stopped eating to listen.

The bull moose had picked up the scent of the wolf!

And stood, aggressive, facing the predator
Staring undaunted into its eyes.
His ears laid back, he lowered his head,
 hackles raised,
And charged!

The bull kicked the wolf with his sharp hooves
The canine was startled
The moose ran then
With his long legs he moved swiftly through
 the high brush
With ease, stepping over felled trees
And made some distance from the wolf in chase.

He ran straight into the lake
And dove deep
 . . . five metres down.

The wolf arrived at the shore
 . . . uncertain.
Then out in the lake he saw the moose surface
It was a powerful swimmer.

The wolf, incensed,
Sullenly retreated back into the forest.

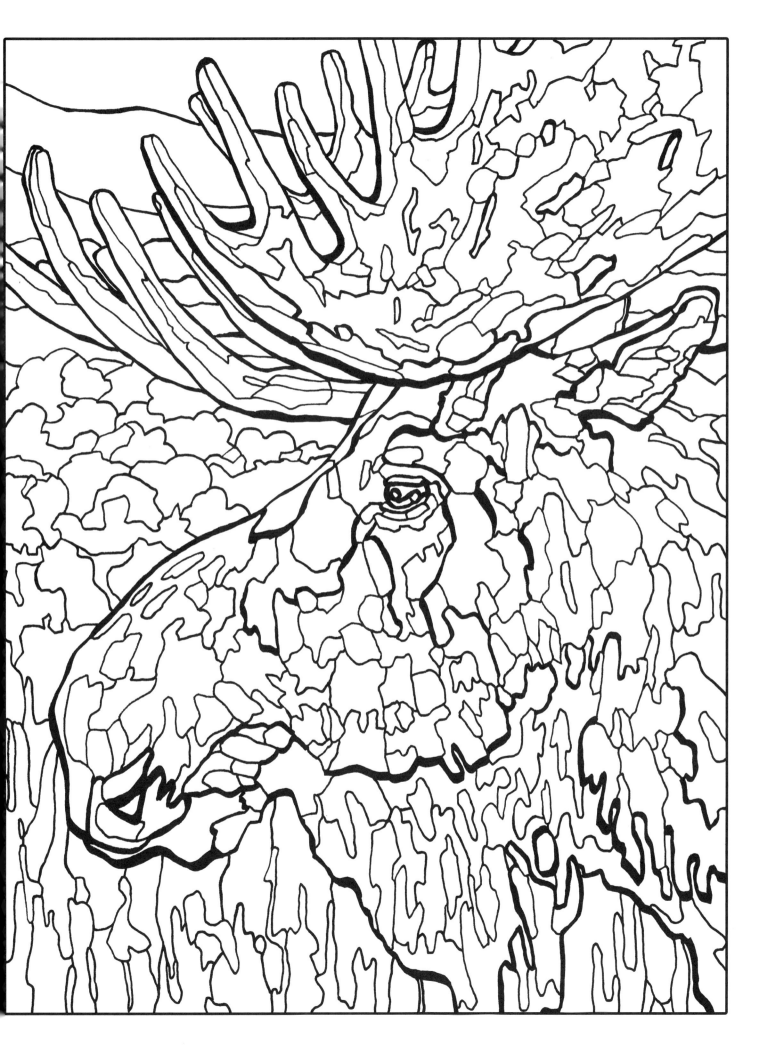

BALD EAGLE

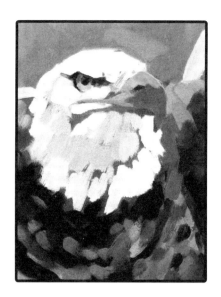

Two chicks peered out of the enormous nest
 atop a pine tree
 that overlooked a blue-green lake
 nestled in the mountain valley.

The eagle swooped in,
 a marmot clutched in its talons.

She tore meat off it
 and fed the hungry eaglets.

Again she took flight,
 soaring through the valley.
She was a powerful flyer.

She followed a meandering stream for miles
 and rose above the mountain peaks
 up into the clouds.

She flew over the lake
And with her extraordinary sight,
 she spotted a fish.
She glided low, talons outstretched
 and scooped up the huge rainbow trout.

As she climbed,
 another eagle appeared
 and dove at her, trying to steal her catch.

He locked a talon with hers
And they spiralled downward.

Their yellow claws released
Just before they hit the water.

The fish dropped.
A third eagle dove for it
She flew hard at the raptor,
Knocking him away with her wing
And snatching up her trout.

The other eagles retreated,
Sensing her determination.

She headed home
And fed her eaglets.
She remained at her nest all night
 protecting them
And their food.

At dawn she took flight again
 and soared
 magnificently!

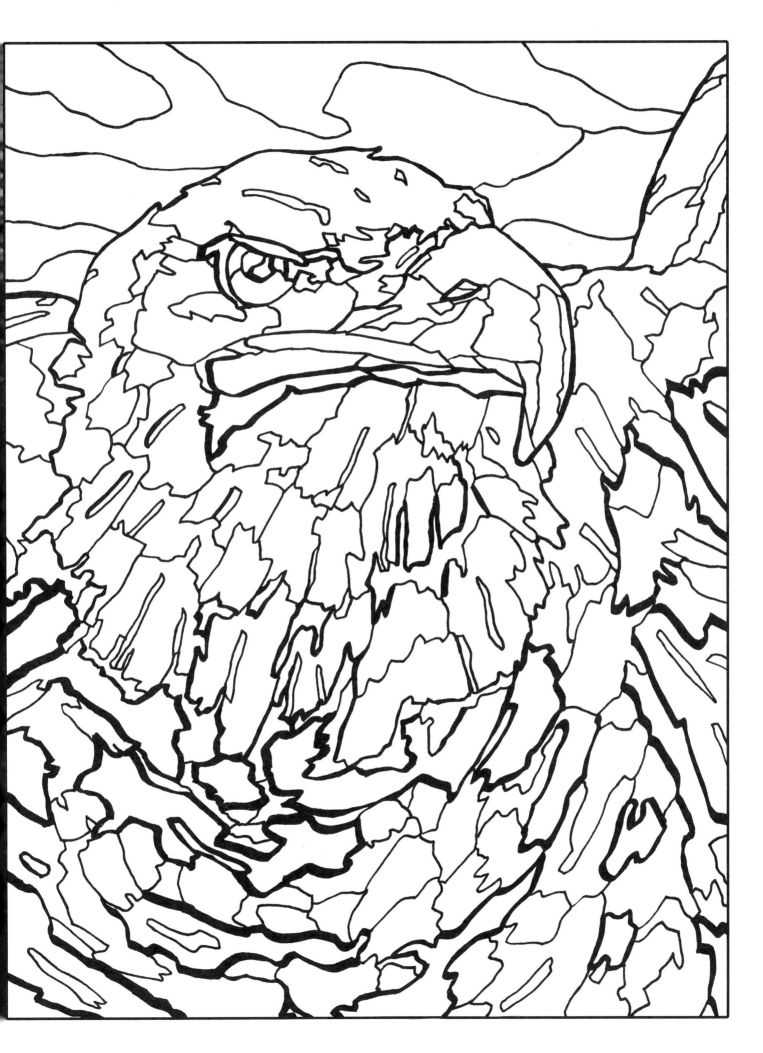

BEAVER

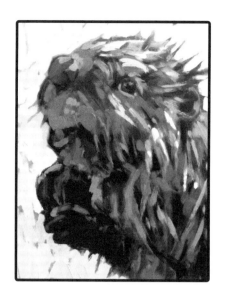

He dove deep,
Sailing through the water,
Using his large flat tail as his rudder.
A transparent layer covered his eyes,
 allowing him to survey his surroundings below.
They would build their home here . . .
Though the current was swift,
 they could change that.

He was a true visionary.

The beavers felled trees in minutes
 using their powerful jaws;
Gnawing with their strong teeth,
 they dragged and channelled,
 and floated logs and branches,
 to their place in river,
 where they created a massive log jam.

They had diverted the water flow
They could now build their home.

The family were nine in all,
 and together
 they gathered leaves, twigs, roots, plants,
 grass, and mud.

They carried it in their paws and teeth and floated
 it down on mudslides and water channels.
And then they weaved it masterfully,
Building their lodge.

It was dawn.
The family of beavers were at the riverbank
 busily rolling lily pads.

One heard the intruder;
A lynx sat poised atop the lodge!
The father slapped his tail on the surface of
 the water to warn the others;
All quickly dove, disappearing into the river.

The sleek cat was patient;
She paced and watched,
Knowing the beavers would surface soon.

Unbeknownst to her,
 they had escaped through their
 underwater entrance,
 into the chambers of their lodge.

There they chewed on leaves
And groomed one another.
Safe in their fortress.

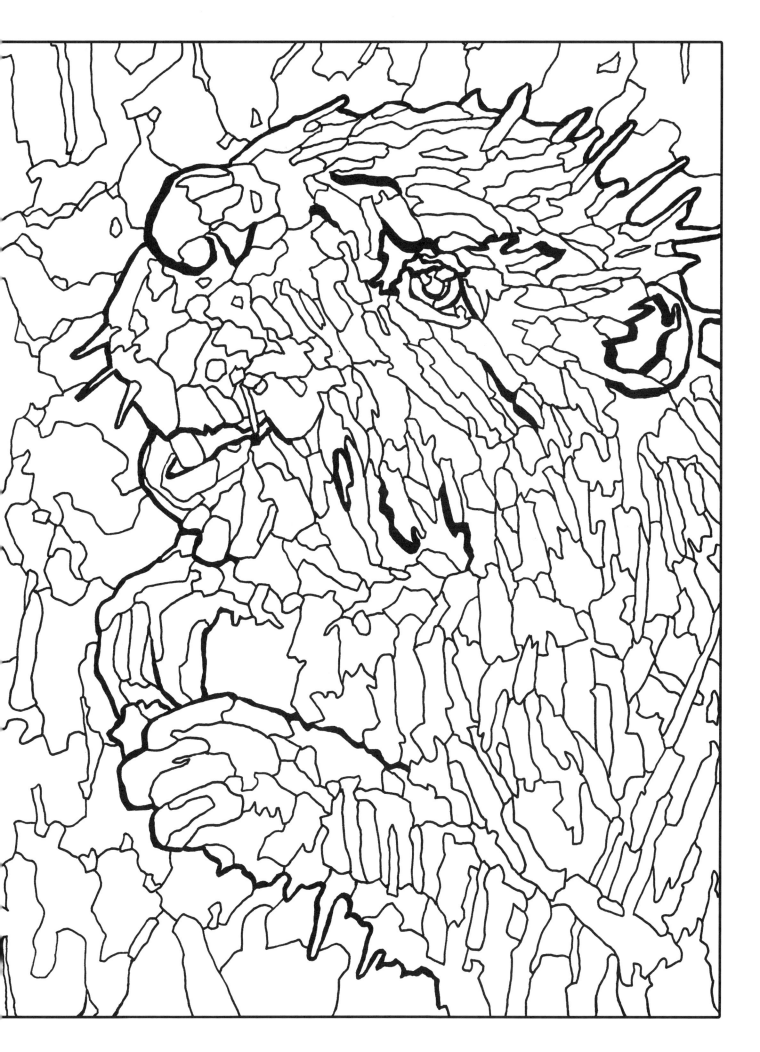

GRIZZLY BEAR

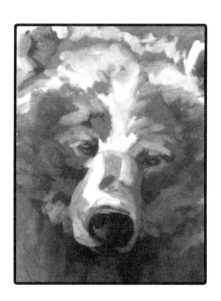

She had trekked many miles,
Ascended high up the mountain slope,
 to find a place
 to make her den.

The grizzly's hump made her upper body strong, and,
With her long, sharp claws,
She was an exceptional digger.

The sow dug,
 tossed boulders,
 chewed through roots,
And made her lair.

She waited till after a fierce storm,
Then she entered her den.
For the heavy snow provided insulation.

But to have made this arduous journey,
 to have prepared for the long winter to come . . .

She had eaten the grasses
 the roots and bulbs
 dandelions and clover.
She flipped rocks and licked up ants
And pilfered the pine nuts that the squirrels
 had stashed away.

With her lips she stripped buffalo
 berries off bushes
 and ingested more than a hundred
 thousand a day.

She dug up ground squirrels,
 chasing
 pouncing . . . trapping
 . . . and devouring.

She fished mountain streams
And trapped trout in her paws.

She killed deer,
 then fought off the wolves
 who wanted her catch.

She had sensed the changing of the seasons
 and she had prepared for her journey.

And, come spring,
 two robust cubs
 gingerly followed her out of the den.

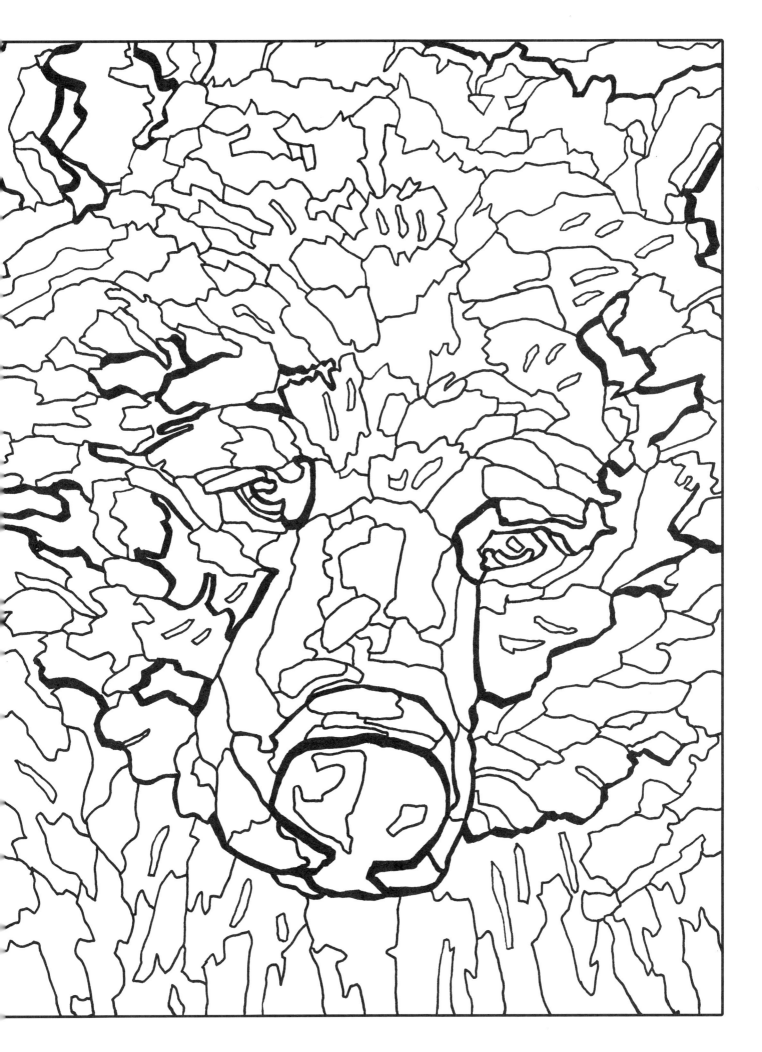

M O U S E

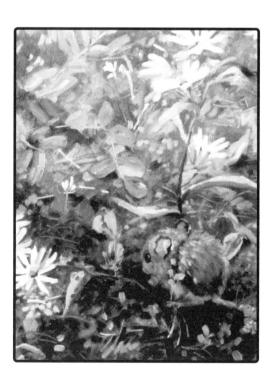

The wee mouse bounded over twigs
Like a deer might clear fallen trees,
Its huge dark eyes
As transfixing as a doe's.

Her large round ears
Alerted her to the fox
Investigating nearby.

The mouse quietly disappeared into a hole,
Just escaping the paws
That pounced upon the ground above her.

She sped through the tunnel below.
It branched off
And she diverted to one side.

Yet the fox sensed where she was,
Following along the ground just above her.

Dirt crumbled from the ceiling
The tunnel was collapsing.

She sprang to the surface;
The fox awaited.
She tried to scamper away,
But his paw held her long tail.

Panting, hot breath
And big teeth enclosed her;
She wriggled,
Frantically digging down with her little paws,
Squirming through some roots . . .

She escaped!

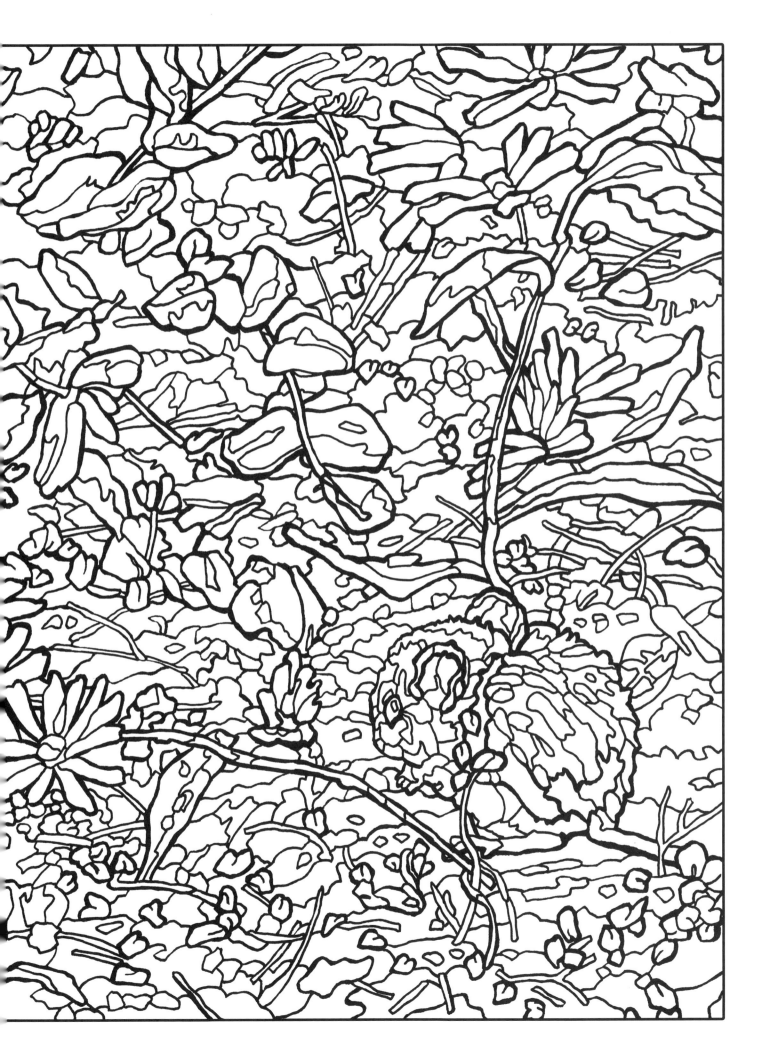

MOUNTAIN GOAT

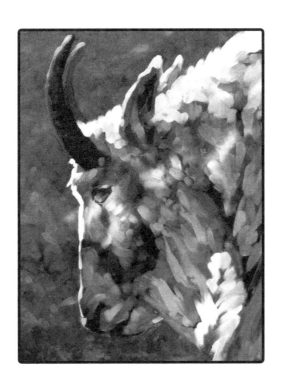

The kid stumbled,
 slipping off the boulder,
 and landing on all fours.
He did so instinctively,
For he was hours old.

His nanny stood below
Readying for a free fall.
She bleated
Then led the kid under an outcrop of bushes
 and fed him.

When he woke they began to climb again,
Their two-toed hooves spread wide,
Their rough pads gripping the rock face,
Allowing for an astonishingly steep climb.

The kid, though stumbling, was determined.
His mother exuded confidence
That inspired the baby goat,
And so he pressed on.

Few predators could reach their heights.

Later the nanny rested at a mineral lick
Her attention away from her kid
But she would catch a glimpse
 of a shadow overhead.

Instantly she leapt
 ten feet,
 landing surefooted,
 overtop her kid.

Just then, a massive golden eagle swooped down
Claws forward, outstretched,
But it was denied its target.

The mountain goat stood sturdy,
 confident,
 fearless.

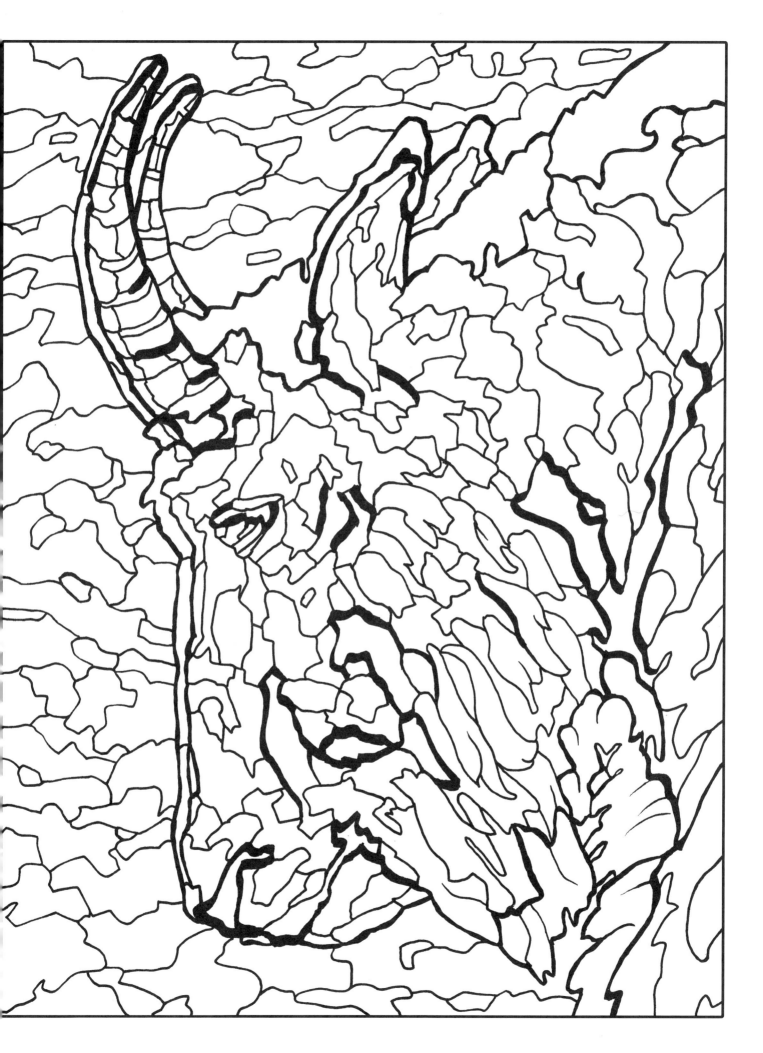

BOBCAT

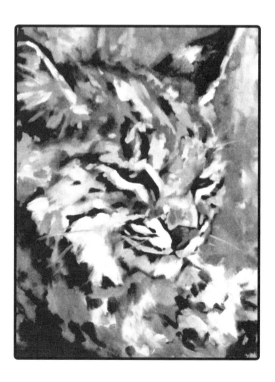

The spotted cat emerged from a hollow log,
 stretched . . . yawned.
He was quite distinguished with his black tufted ears.

His pupils widened,
 enhancing his keen night vision,
But he had already sensed the fox
 waiting in the brush.

He took off like an arrow
Making his escape up into the trees.
The fox arrived late,
 vexed as it searched the empty shelter.
And soon left
 in pursuit of a hare.

The bobcat wandered
Savouring his solitude
 until sunrise,
When he came upon several geese.

He moved silently through bushes,
 crouched, and remained motionless behind
 a boulder,
Watching . . .

The geese sat upon an island in a pond,
But he had no desire to swim;
Eventually they would come to shore,
 where there would be an ambush.
With his muscular hind legs
 he would sprint,
 and pounce.

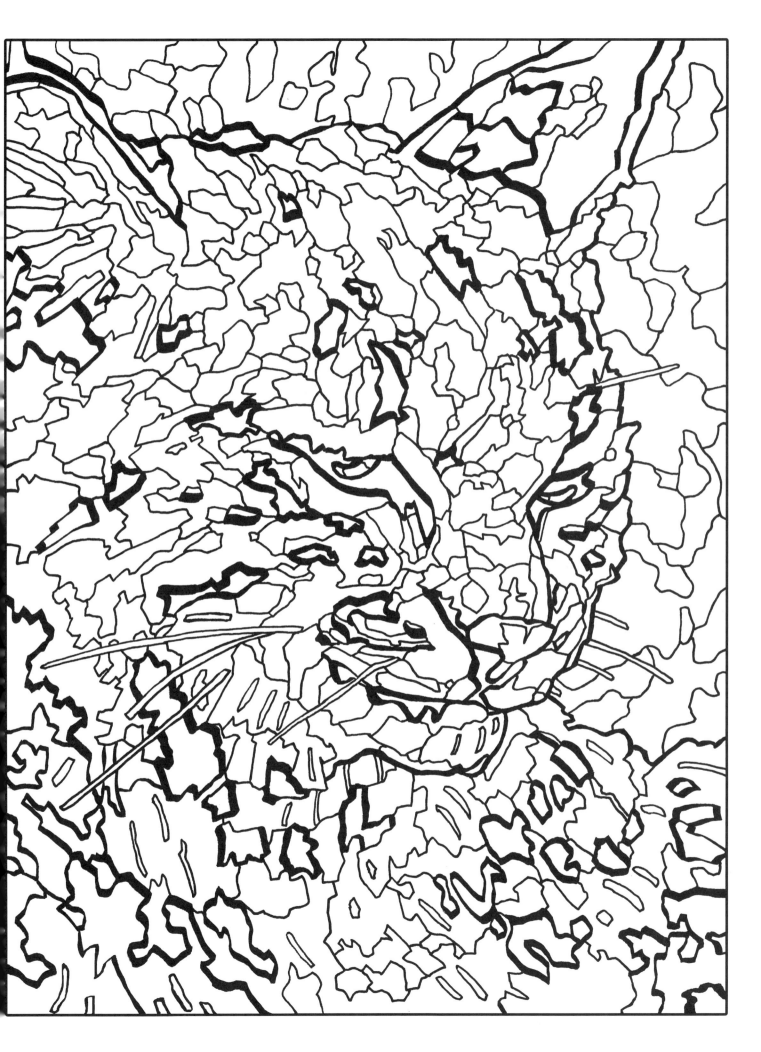

WILD HORSE

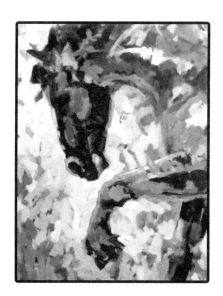

The wild stallion was magnificent
His mane, long and shaggy,
 covered his eyes
 and it fell lazily over his back.
His legs were strong,
 with rippling muscles.

He followed behind his herd
Protecting them from a predator's approach.
Holding his head high, he squealed loudly
And the other horses turned to follow.

He led them to a watering hole
 and into the woods,
 where they sought shade from the sweltering heat.

While they rested,
A bored, cocky young stud
Challenged the stallion,
 his ears laid back on his head
 as he stared fiercely.

The stallion responded,
 first lowering his head, pawing at the ground . . .
 and then turning and lightly kicking at the stud.
The stud nipped at the stallion,
 who reared, neighing angrily.

In the commotion, a foal ran scared;
His mare heard his frantic neighs and
 disappeared after him.

But the stallion sensed danger;
The herd of horses took flight,
Except for the mare and colt.
Now together each hid behind a tree,
 remaining perfectly still.

A cougar crouched high up on a branch
And sprung out at the young colt,
But the stallion charged in
 taking the assault.

He would sacrifice himself for any of his family.
He kicked out savagely at the massive cat,
Screaming sounds erupting from both.
He stomped, bit . . .
And the cougar ran off.

The lion's claws had cut deeply
But the stallion would survive.
The majestic creature ran like the wind
To find his family,
 who nickered and neighed at his arrival.

The young stud bowed his head
To their champion.

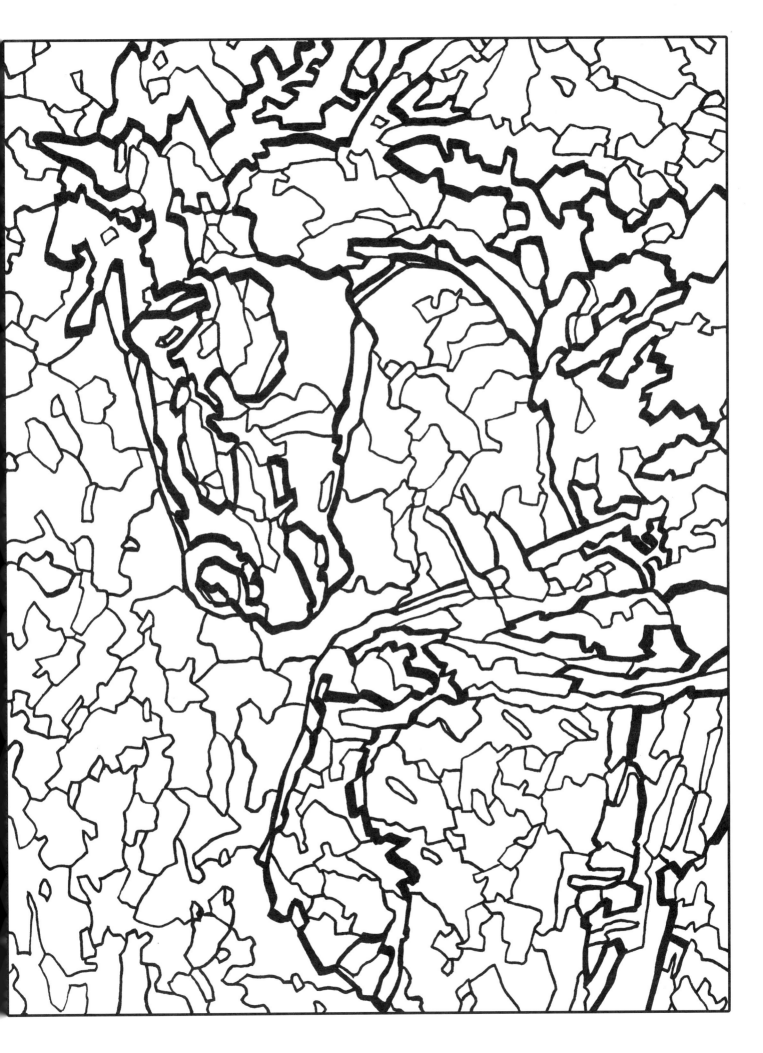

BISON

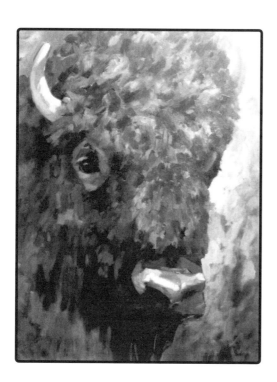

It was dusk.
The herd meandered,
grazing the prairie grass.
Young bulls played at the river.

Content, ever grateful,
 for the natural abundance of life
 that encompassed them.

But then . . .
The cow picked up its scent.
It was immediate,
And with her keen sight,
 she spied the grizzly coming through the trees.
It was going to kill a young bull!

The buffalo snorted angrily and growled;
A mournful bellow came from a calf
 and the lazy herd suddenly came alive!
Like lightning,
 the massive beasts stampeded!
The reverberating sound of hooves . . .
 the ground trembling.

One bison reached the bear and turned,
 savagely kicking it with its hind legs.
Another lowered its head and gouged the bear
 with its sharp horn.

The bear sprinted away,
 escaping into the forest.

And the buffalo grazed.

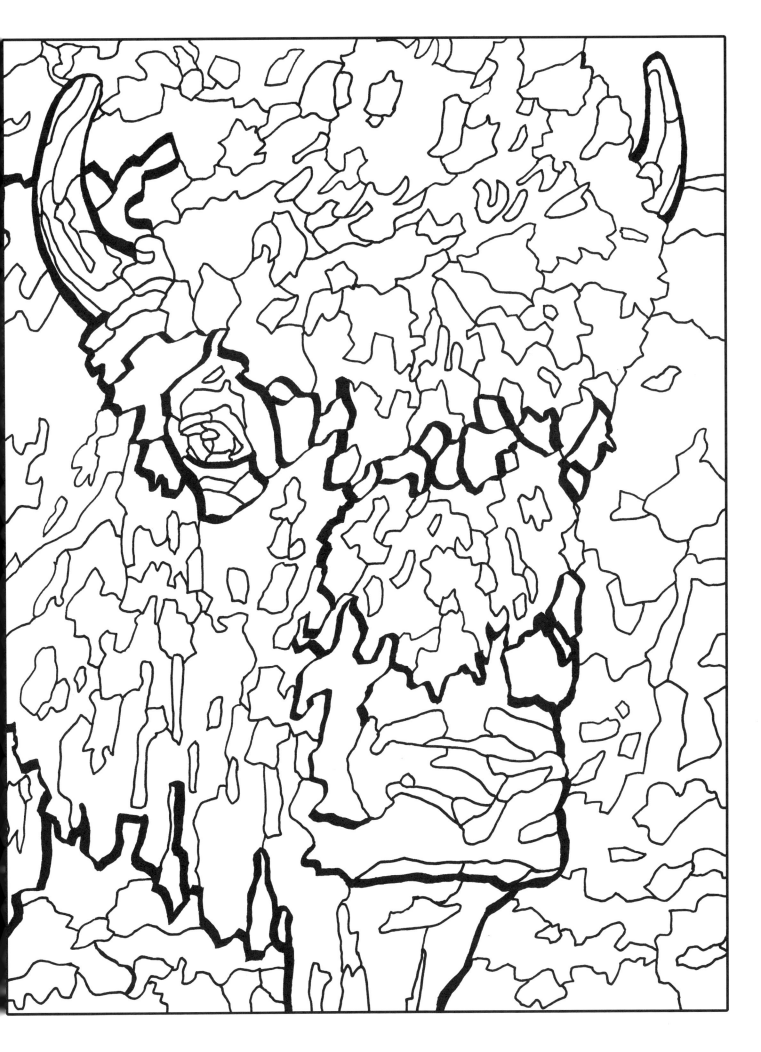

RED FOX

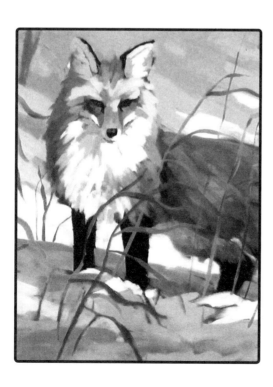

The fox emerged from her den
 and yawned.
She heard the mouse below the ground
And skittered overtop, moving along with it,
 then pounced.

Within minutes she caught another.

Then, in the distance,
 she heard the cry of hounds . . . approaching!
She dashed down the hill
 into the forest,
 nearly colliding with one of her pursuers.

She scampered straight up a tree
 and rested on a branch,
 panting
While the hound stood on its hind legs,
 scratching at the bark.

Hearing the rest of the pack draw near
The vixen leapt from the tree
 disappearing into a tunnel.
The pack of hounds arrived, frantic, searching.
They spotted the red bushy tail ahead
 and wildly continued their pursuit.

The vixen crossed a stream,
 doubled back on her trail,
 baffling the hounds.
They had gone in a circle . . .

But the fox was tiring;
The hounds would outlast her.
But cunning she was,
 leading them to a fence.

She sprang seven feet,
 up and over.
And she turned and smiled at them.

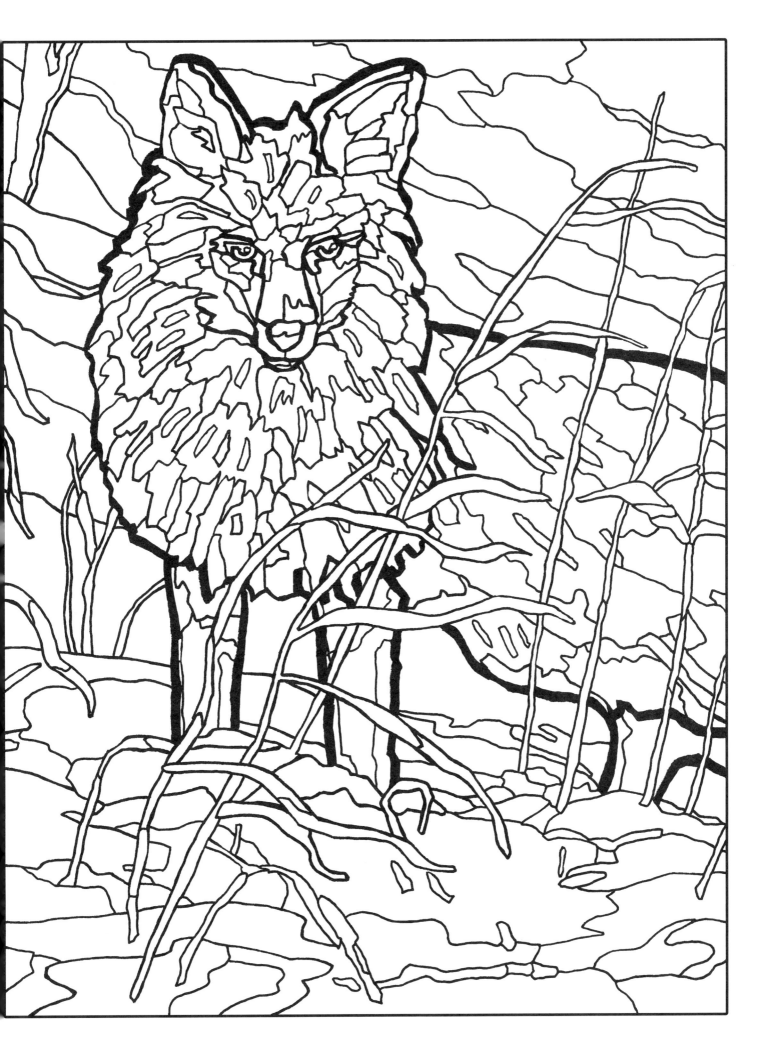

FOX

CUB

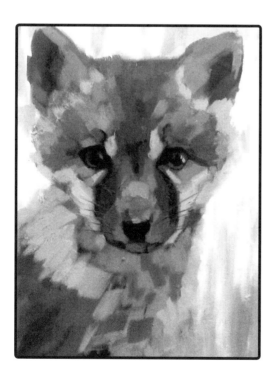

The night was dark and bitterly cold.
The kit followed his mother under the enclosure.

Far into a corner they nestled together for the night
 using their fluffy tails to cover and warm their
 noses and feet.

In the early light,
 out of the home above clambered a puppy
 tumbling into the snow.
The young fox watched through a gap in the wood.
He dashed out and wrestled the puppy down.

Furious, the vixen warned her kit with
 high-pitched yelps
And she sprinted into the forest,
 expecting him to follow.

But instead the kit chased the pup
 into the meadow.
It was a long while before the dog returned home
And the kit dared return to his mother.

And though he was reprimanded
On the sunrise to follow
He waited for the pup to come out again to play.

The vixen knew better and retreated alone
 to the forest.

For nearly a fortnight, the pair carried on this ruckus.

It would take three coyotes
 hanging at the edge of the woods,
 stalking the youngsters.
That was the warning
 the fox kit heeded.

He sprinted away
 to find a new lair.

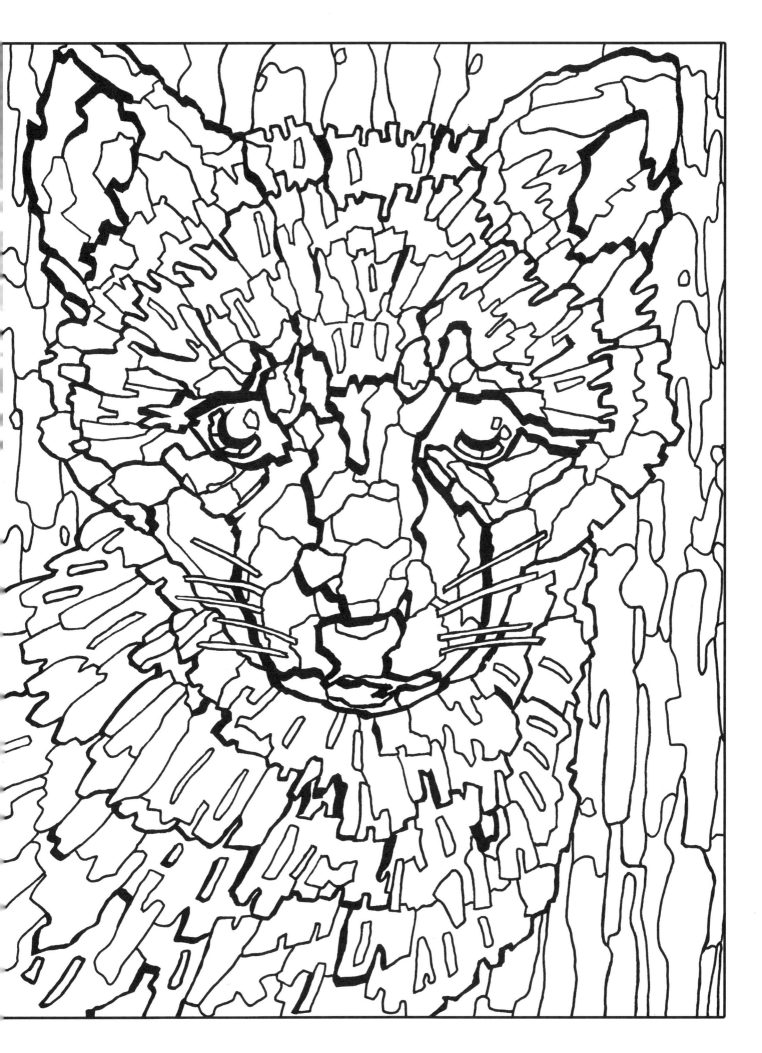

COUGAR

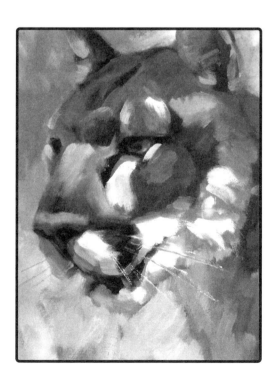

It was dusk.

She was slender and agile
 and slinked through the underbrush
 soundlessly . . .

She emerged from the trees,
 and continued to prowl in between the rocks.
It had been nearly a fortnight since she had
 last feasted.

The coyotes sensed the danger.
Facing out they formed a circle,
 watching from every direction,
 fearing an ambush.

But the cougar was a master of camouflage.

The coyotes skittered and moved high up along
 a cliff, feeling more secure.

The cat was patient.

A chirp . . .

The massive lion sprang from below.
In one bound she had leapt fifteen feet,
 landing on the back of a coyote.
Her huge jaw and long sharp teeth grasped and
 broke its neck
 bringing it down to the ground.

The rest of the pack vanished
And the majestic cat dined until her hunger
 was satisfied,
 then stood proudly, looking out from the cliff.

Later she dragged her catch to a tree well
 and buried it in the dirt and leaves.

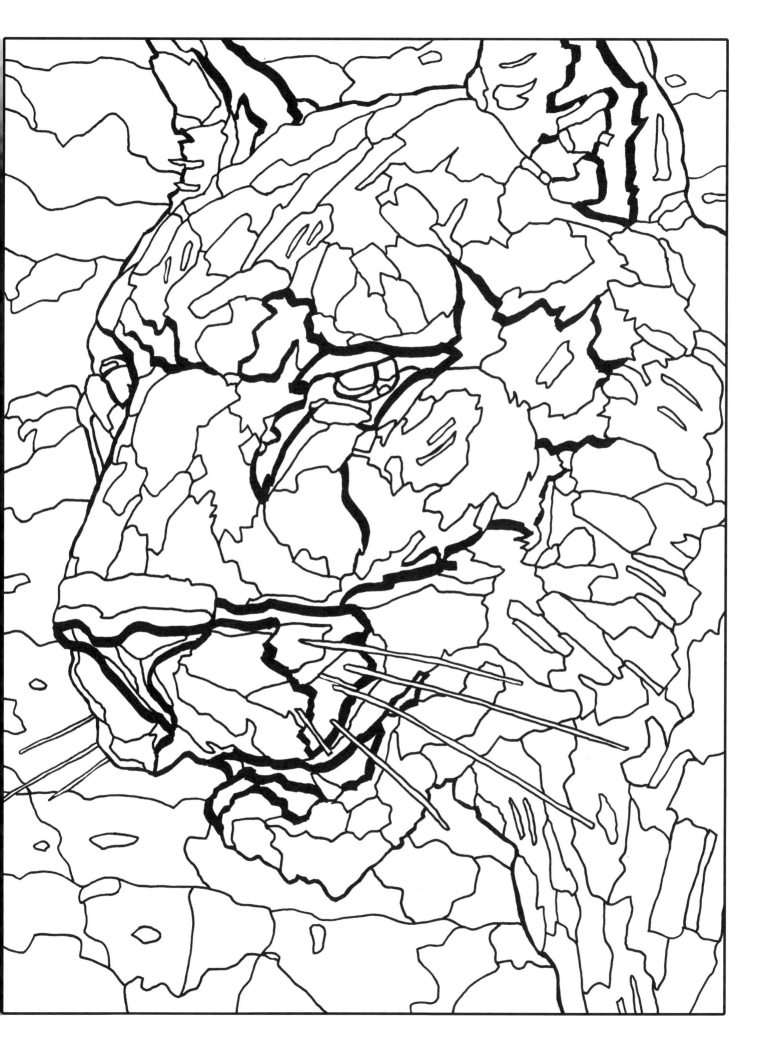

HARE

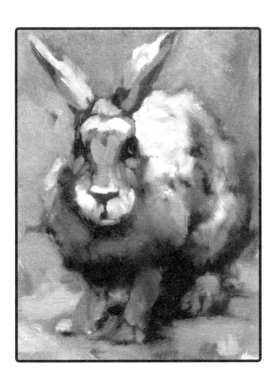

The red-tailed hawk soared
 and spotted the hare.
Its movements were purposefully erratic,
 appearing then vanishing
 through holes of fallen trees.

The hare was aware of the hawk
 but the skittering weasel was her greater concern.
The bold carnivore stood upright and stared;
The hare fretted as her kits were nearby.

She dove into the earth
 and the weasel chased after her into the hole.
The hare left droppings
Then she swiftly changed directions
 dashing down another passage
 confusing the weasel.
Up to the field again,
 she moved in and out of vegetation.

The hawk still circled above
And the weasel reappeared.

The hawk dove,
 its sharp talons outstretched.
And at the same instant
 the weasel leapt at the hare
 the hare disappeared.
The hawk, startled, snatched the weasel.

It had preferred the hare,
 but the vermin would do.

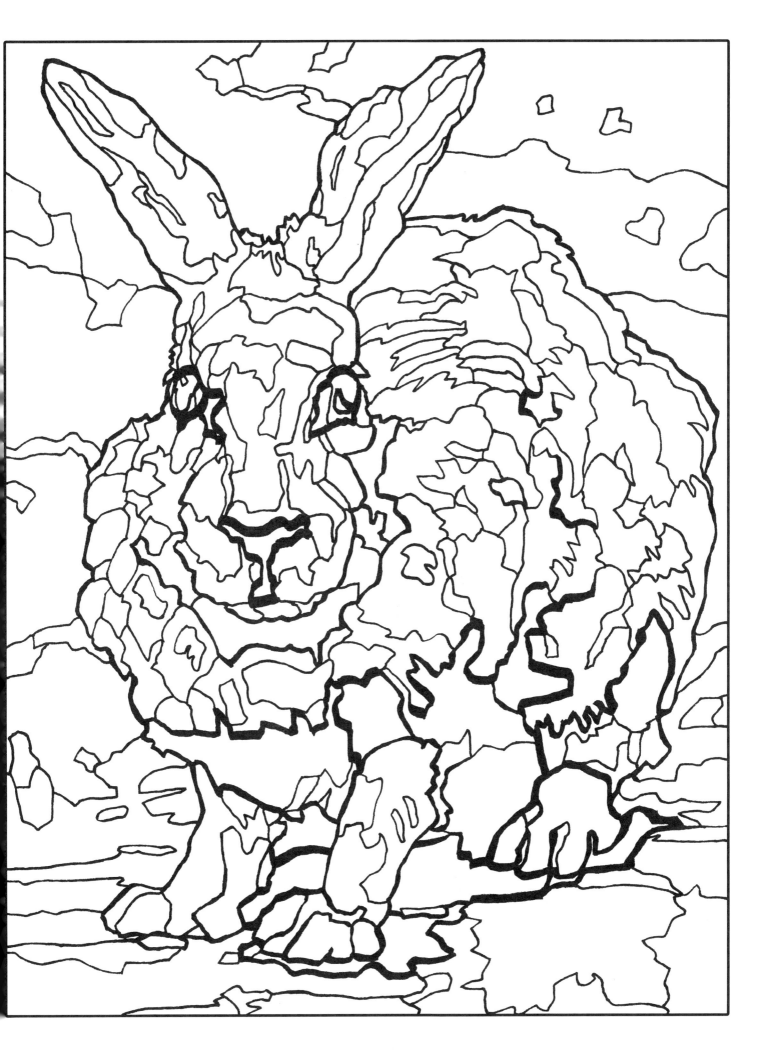

WOLF

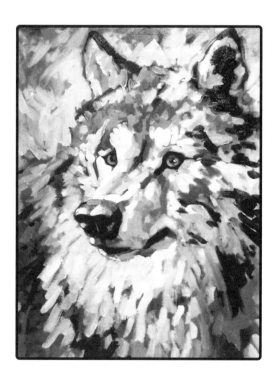

He crept low through the long grass
 then lunged at his brother
The pups tussled and rolled,
 yelping and snarling.

The alpha female growled a warning to another
 that had wandered into the bush after a hare.
The remainder of the pack had left their
 rendezvous area to hunt.

Out of the wilderness, a howl.
She knew it was not of her pack—
 an intruder!
The howl was low pitched, coarse,
 aggressive . . .
Surely the leader of another pack.

Then came another howl, and another,
 but she recognized only one.

She knew her family would fiercely defend them,
 but how many were nearby?
She was alone with six pups
 and she herded them back to their den.

Only two of her pack were close.
They stood tall, hackles raised,
And howled . . . yowled,
 moving in all directions,
 up the hills along the cliff's edge.

Then they howled in chorus,
 the mother joining in.
And the howling echoed and bounced off
 the trees and ridges,
 scattering through the valley.

The alpha male and his pack were taken aback,
 believing they were outnumbered
They retreated.

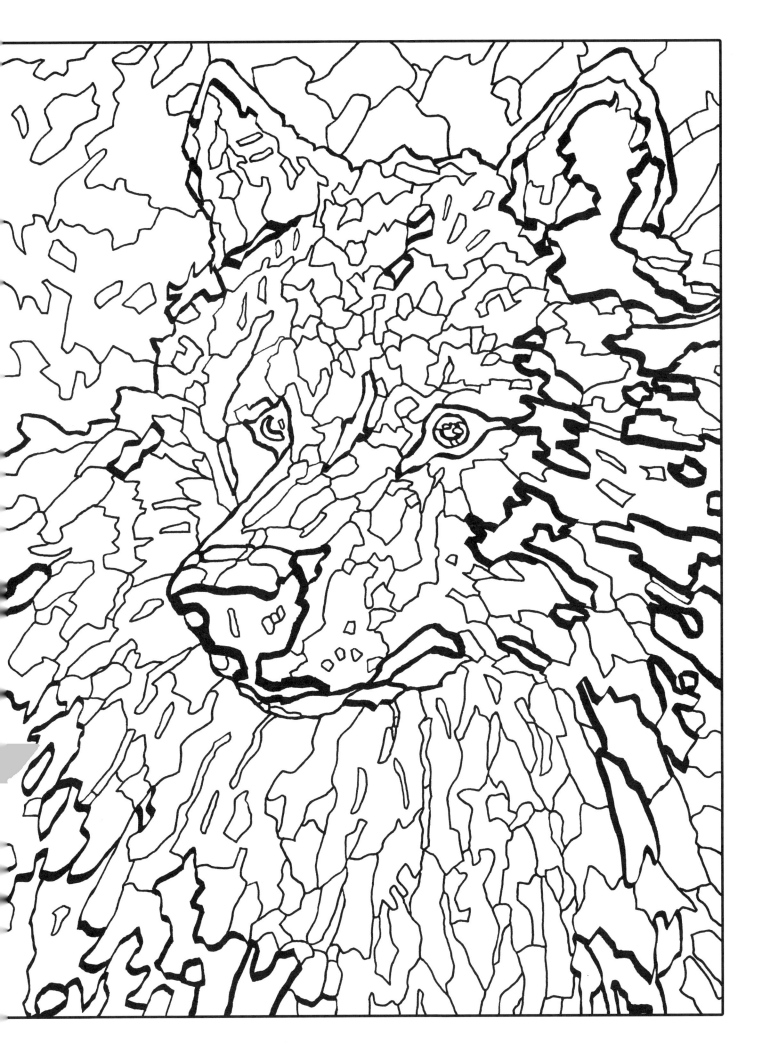

RAVEN

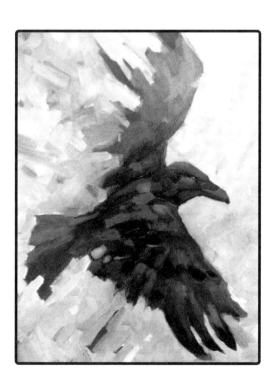

She strutted,
 then moved along, hopping on two feet.
And quite on the sly
 she absconded with a cache of food.
She carried it far off
 and hid it far better.

The raven took flight,
 soaring so gracefully.

She flew in a loop
 and another . . .
Her mate mirrored her motions
Then swerved off . . . disappearing.

She heard a caw
 . . . her call!
He was mimicking her
Delightful!
She dove to him.

He had discovered an elk carcass;
Together they began their high-spirited calls
 to the wolves;
The calls were shrill
 . . . grating.

Soon a pack of wolves emerged from the forest;
At once they tore at the hide and feasted,
 opening the carcass
 for the scavengers who joined in.

They were hunting partners,
 the wolves
 and the ravens.

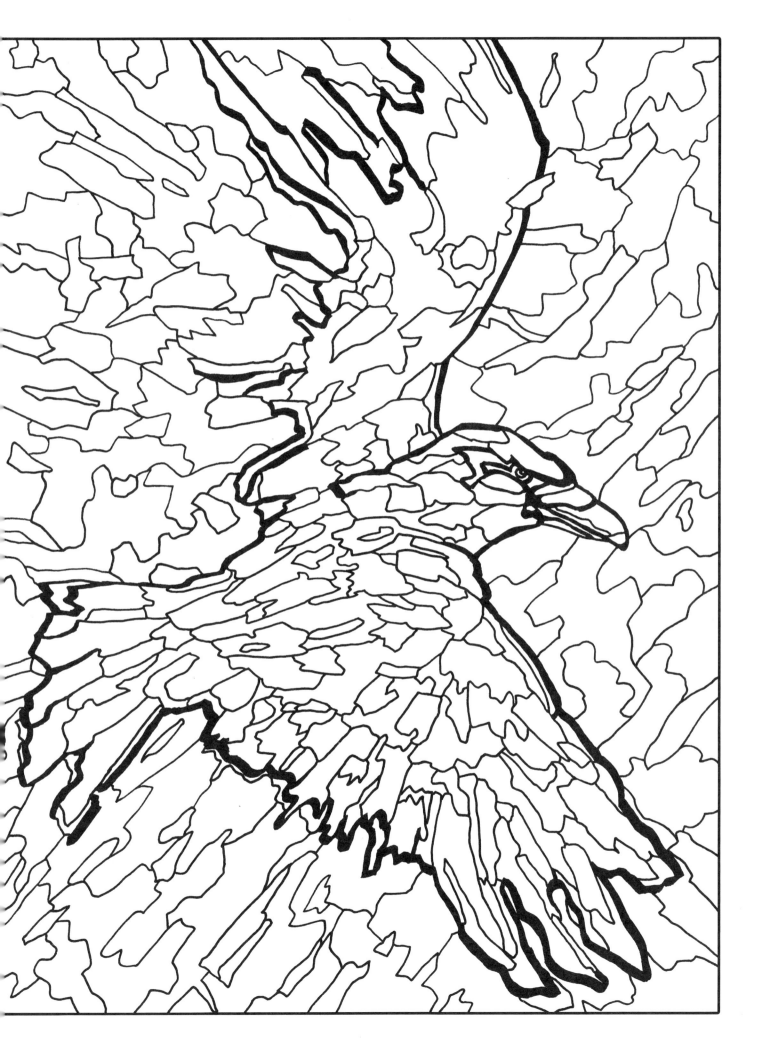

SPIRIT BEAR

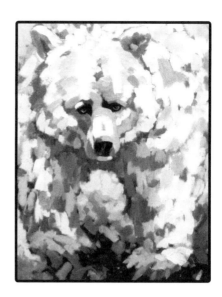

In the Great Bear Rainforest

The Kermode clambered down the bank
 and into the river.
He swam out to the waterfall,
 climbed atop a boulder,
 and looked over the falls, studying the salmon.
They were everywhere,
 jumping up the fall.

The fish seemed to evade his brothers,
 the black bears
But the Kermode's pure white coat
 was not so discernable.
He was also known as the Ghost Bear.

And as the salmon jumped,
He caught the huge fish midair in his jaws.
Then he swam across the stream
 and disappeared into the forest.

Moments later he returned,
 swam out to his place at the falls,
 and caught another fish in his teeth.
When it quit flapping he laid it over a log in the river.

Like a ghost he dove under the water
Reaching, scooping,
 trapping another in his paws.

He crossed the river
 taking the two fish to his secret place.
He did this for hours, and hours.
He consumed seventy-three fish that day.

On one occasion
 a black bear crept upon his stash.
Angrily, the enormous Kermode bear,
 all 500 pounds of him,
 stood tall and bellowed a ferocious growl.
The black bear, terrified, sprinted away.

He was, after all,
 the Great Spirit Bear.

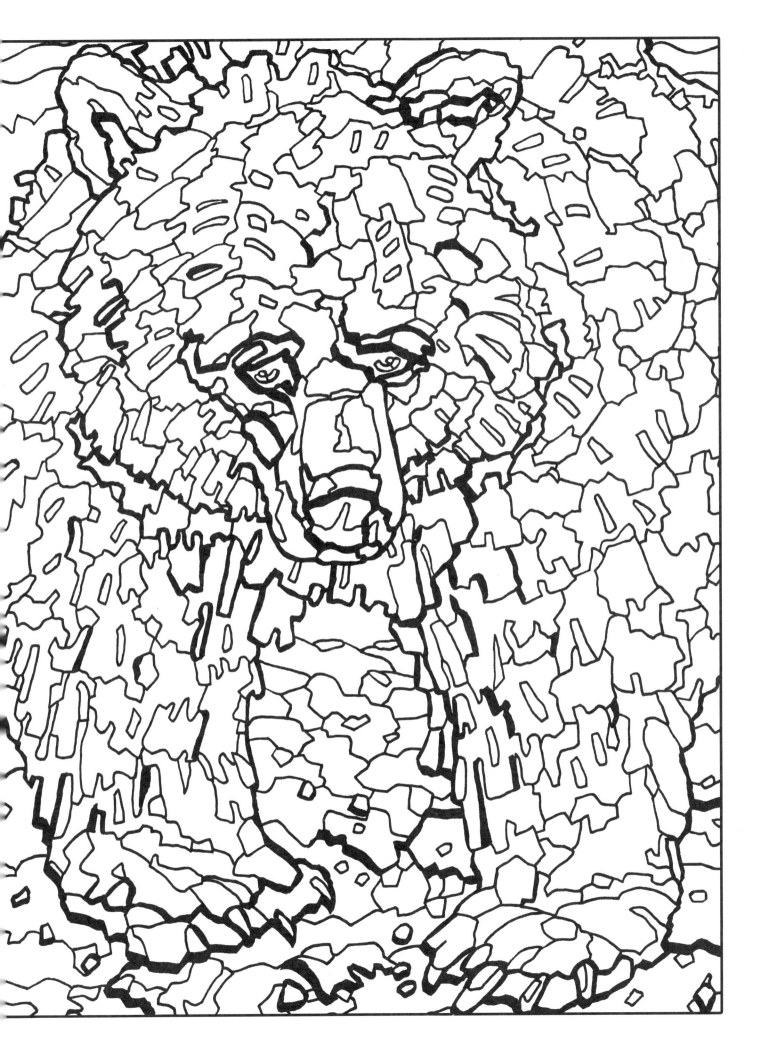

DEER

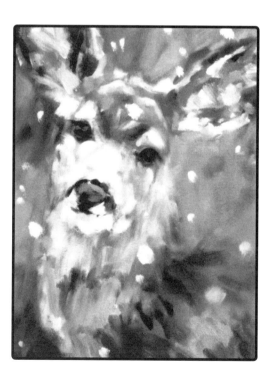

A natural beauty,
 serene
 and graceful.

A twig snapped,
 but she had long sensed the predator.
Now she could see it between the shadows.

Swift and deliberate,
 she made a dash
 away from her fawn that was well hidden
 in the long grass.

The coyote sprang after her
 but she had vanished!
Camouflaged
 and motionless,
 standing strong in her choice,
 not distracted by the creature's yip.

The coyote spotted her in the trees,
 but was transfixed by her gentleness
 and spirit of compassion.
Then he quickly scampered away.

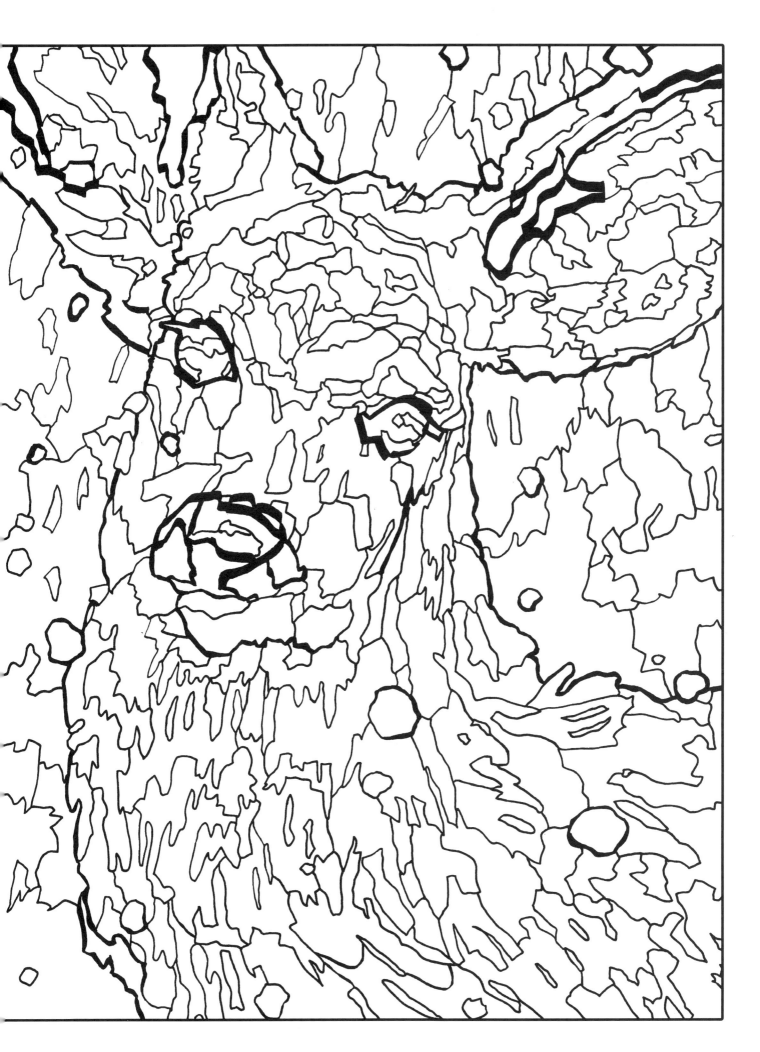

GREAT HORNED OWL

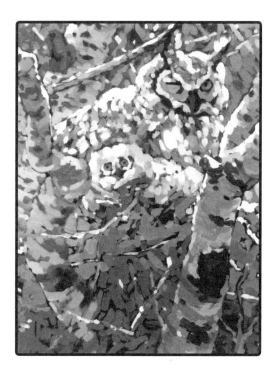

He crouched . . .
 in readiness,
 waiting for her to take flight.
In a flash,
 he would be upon her nest.

A fledgling floundered and stumbled,
 tumbling to the forest floor.
The bobcat . . . lightning-fast . . .
 pounced!

But the great horned owl
 knew the danger lurking below.
It was simply intuitive for her
 in the black of the night.

The cat heard nothing
 for the owl's flight
 was stealth.
She swooped down
And her powerful talons
 found their mark.

Her owlet was safe from harm.

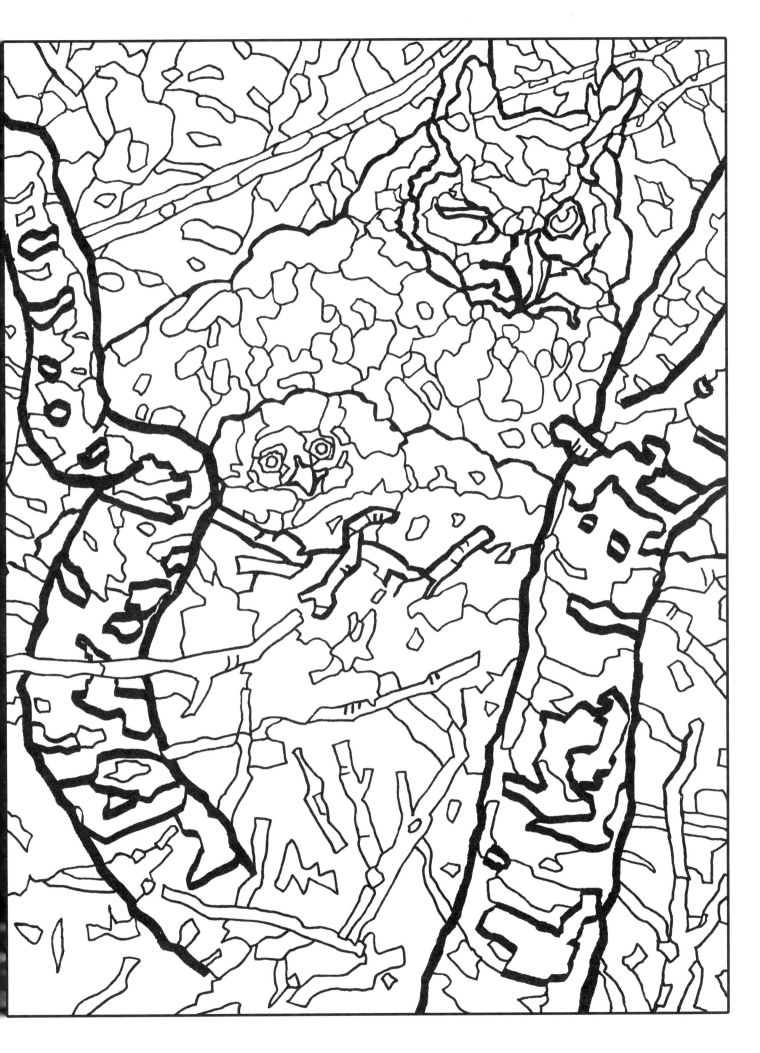

BIG HORNED SHEEP

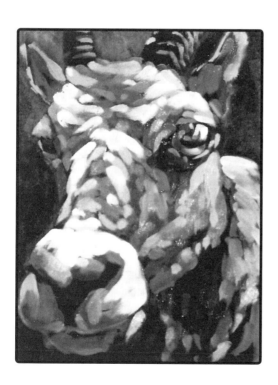

The ewes listened . . .
The clashing of horns echoed through
 the mountains.
The rams had gathered
And battles ensued.

The ram's massive curved horns
 were the largest of all.
He was the oldest of the herd.

He nonchalantly nibbled on leaves
 . . . red as the chill of fall had settled in . . .
And then he turned and charged!
He hurled himself at another ram
 who had dared challenge him.
They collided with reverberating cracks.

Retreating, then turning,
 they charged at one another again,
 heads and horns crashing.
It went on for hours.
Eventually the younger ram
 collapsed in exhaustion.
The ewes in the distance
 noticed the silence.

And soon, when the rams and ewes gathered
 for mating season,
 the females easily recognized the dominant ram.
As so he did strut.

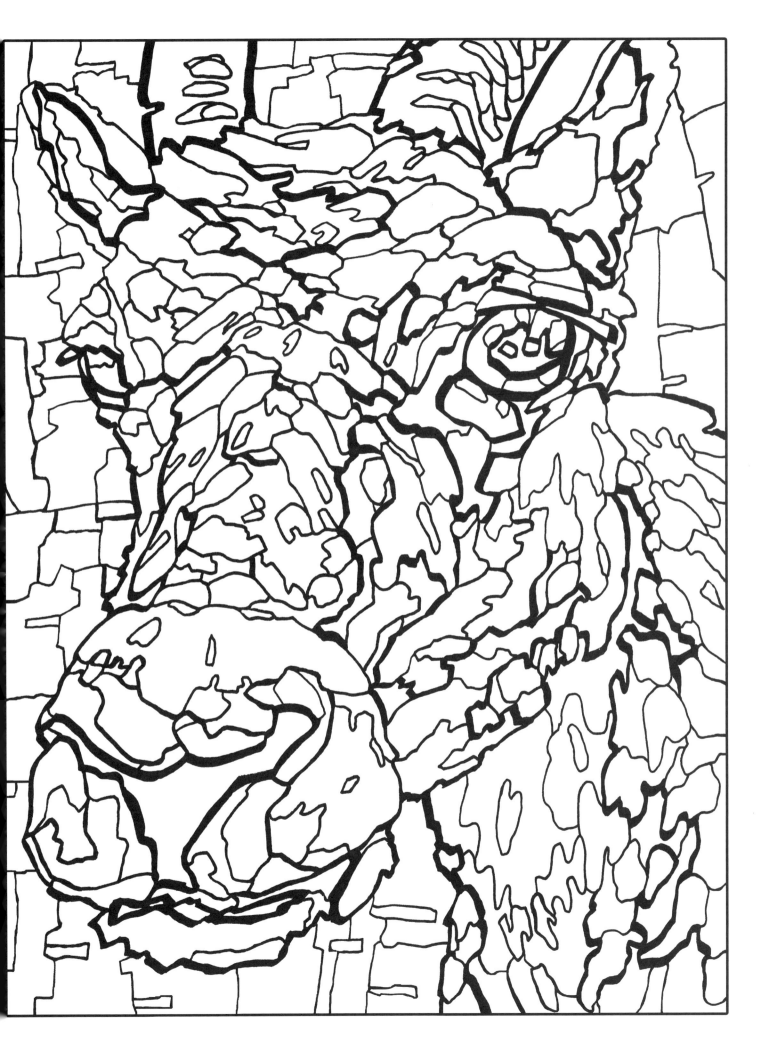

SALMON

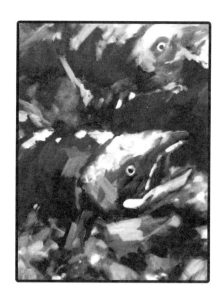

She wriggled out from between the pebbles
And she was up and away
 into the free water.
She drifted, then began to swim.

Stripes ran down the little parr's body
 providing camouflage.
Very few of her kind survived,
 but she would be one.

She travelled far downstream
 until she could taste the brackish water.
Then into the sea she sailed . . .
There she would live for more than four years.

She grew quickly,
 consuming plankton, shrimp, small fish.
There was plenty.

Then, it was time.
A hump had grown upon her back;
She had formed canine teeth;
And her skin had darkened.

She began a great journey;
A thousand miles through the sea she swam
 to find the river she had entered from.

Up this river she swam,
 against the current, relentlessly,
 evading birds of prey,
 for a hundred miles or more.

At the waterfalls she swam beneath the strong current,
 into the reverse current below.
Then she jumped the falls
 somehow escaping the grizzlies,
 jaws open, chomping at her.

After the falls
 her body scarred, ragged, exhausted,
 she arrived at the very place she began.

She turned on her side
 and back and forth she fanned her tail.
She scooped out a hollow
 making her redd
 where she laid her eggs.

And while her body gave out
 and drifted down the river
 she remained at her nest.
There she lived on
 through her spawn.

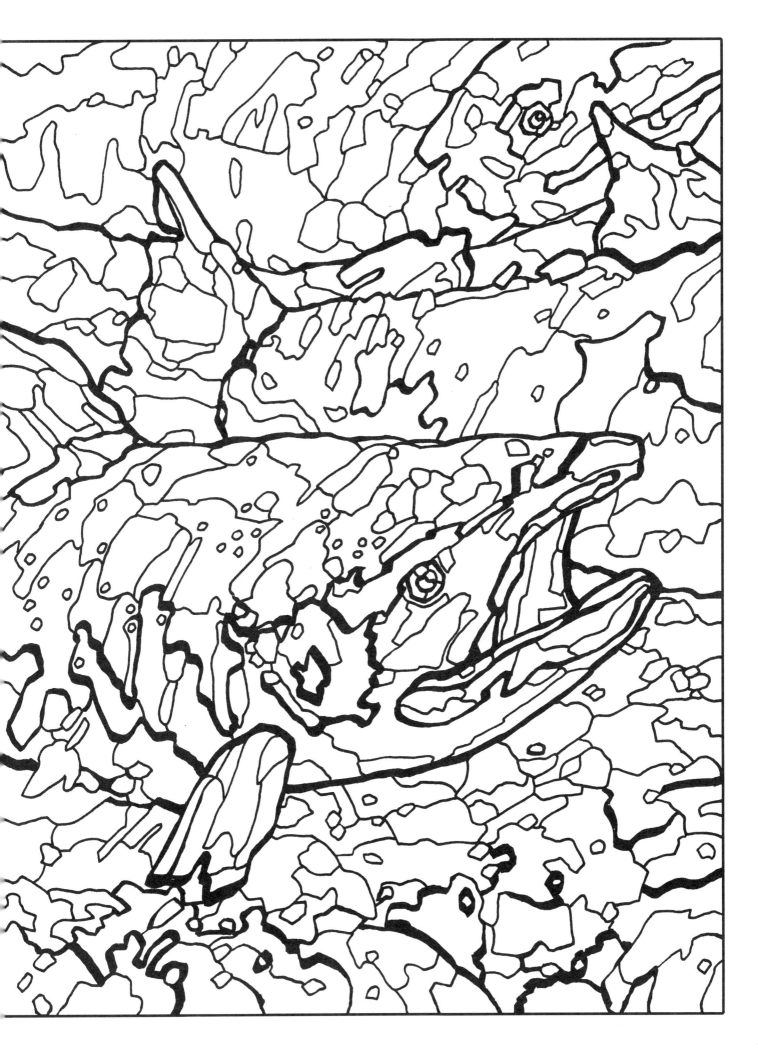

RED-TAILED HAWK

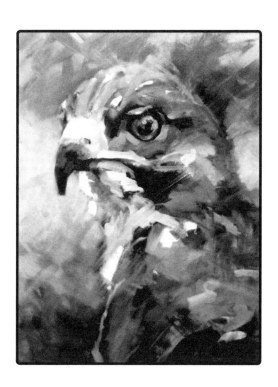

His wings beat slowly,
 deliberately . . .
Steeply he climbed,
 then dove towards the earth.
He began his ascent again,
 all to impress her.

Together they soared and glided in wide circles.
In midair, he grabbed her talons.
They spiralled together, falling . . .
And from their red tail feathers,
 a passionate energy and spirit emanated.

Their cries were shrill,
 rasping screams . . .
Knee-eeeee-ar!

Just before hitting the ground they pulled away.

Upon a cliff overhang they built their nest
 of pine needles, bark, and plant matter.

And above the prairie they soared,
 hovering . . .
With their powerful vision they hunted
 then dove,
 swooping down,
 catching gophers in their clutches
 and feeding them to their young.

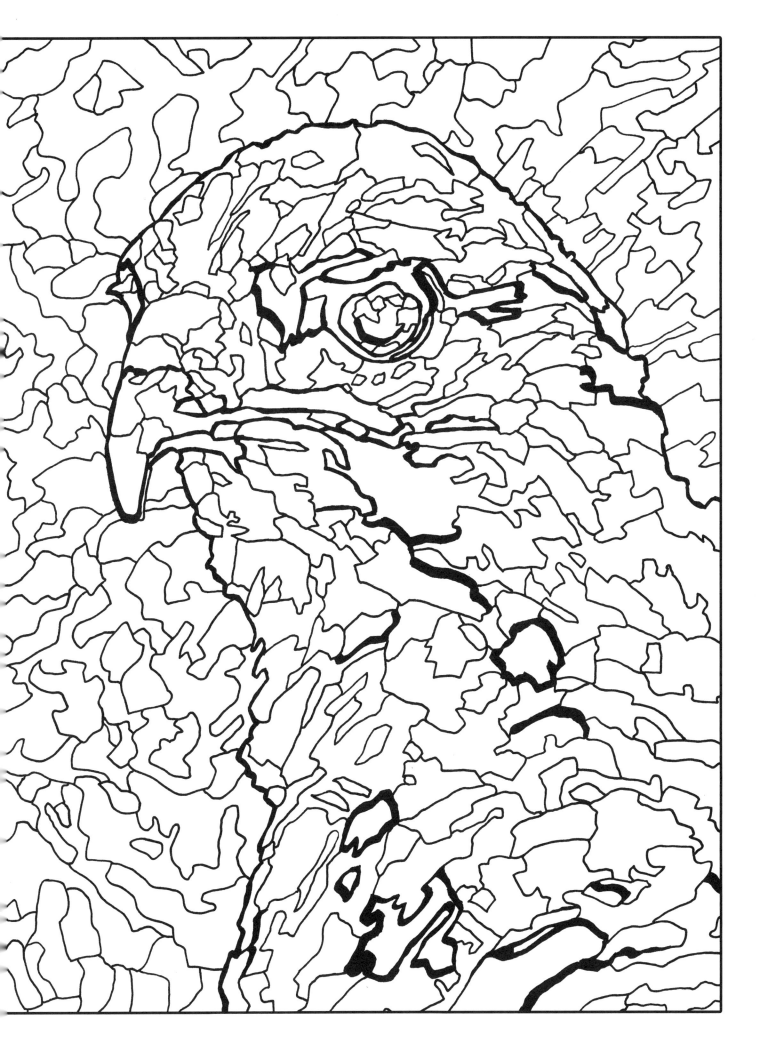

BLACK
BEAR

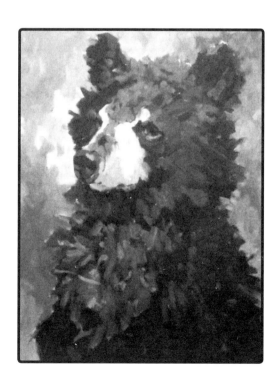

Though he had clambered up the tree with
 ease he could not get down.
Hearing his fretting and wailing,
 his mother was fast upon him.
Gently grasping him in her jaws,
 she lifted him down
 and cradled him in her paws
Then she licked his head.

He pulled away and chased after his brother.
The cubs stood on their hind legs
 sparring, wresting to the ground
 they rolled . . .
When it got too rough
Mama Bear walloped one,
 breaking it up.

She led them across the river
And with their powerful legs, they swam through
 the strong current
 reaching the saskatoon berries that grew along
 the bank.

She showed them what berries were safe to eat
And with her sharp teeth and claws,
 she killed small animals,
 teaching them to hunt.

Even when they all slept,
 . . . deeply . . .
 snuggled up to her warm body,
 she protected them.

When the cougar approached she awoke
 and growled
 and roared ferociously
 and attacked!

Her love for her cubs was fierce and protective.
And her indomitable spirit
 lived through them.

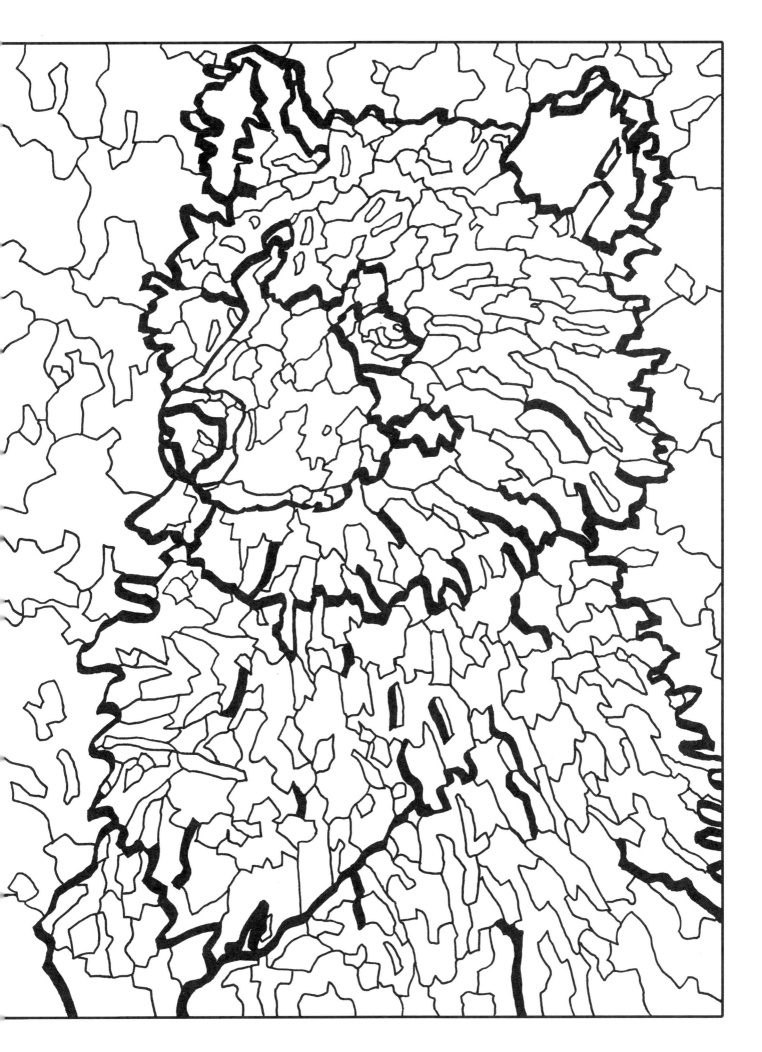

ACKNOWLEDGEMENTS

Thank you to Gary, Peta, and the entire ever-patient family. Eternal gratitude to my friends and students for your support and encouragement. Thank you to Michelle Holland Photography, Jett Britnell Photographics, and Clint Silzer Photography for the photos that allowed me to study the more elusive animals closely. Thank you to Heritage House Publishing and Lara Kordic for this fantastic opportunity. **—Erica Neumann**

Great thanks to Petra and Kalissa for all their support. To Erica, your beautiful artwork is my inspiration. I dedicate this book to all of you and my incredible children, Mikayla, Jeremy, Emily, and Katrina. **—Dawn Sprung**

ERICA NEUMANN, A.O.C.A., is the painter of the Original Bow Valley Bears, exhibited in the Rocky Mountain towns of Canmore and Banff since the mid-1990s. Erica's distinctive paintings of Canadian wildlife are very well known throughout the region, and they are admired both in public displays and private collections locally and worldwide. Learn more at ericaneumann.com.

DAWN SPRUNG has a lifelong passion for storytelling and the outdoors. She lives on a ranch in southern Alberta, where the land and wildlife at her doorstep constantly inspire her. She is the author of *The Legend of the Buffalo Stone* (with illustrator Charles Bullshields) and (under her former surname, Welykochy) *C Is for Chinook* (with illustrator Lorna Bennett).

Heritage House Publishing Company Ltd.
heritagehouse.ca

978-1-77203-115-7 (pbk)

Cover and interior book design by Jacqui Thomas
Cover and interior illustrations by Erica Neumann

The interior of this book was produced on FSC®-certified, 30% post-consumer recycled paper, processed chlorine free and printed with vegetable-based inks.

Heritage House acknowledges the financial support for its publishing program from the Government of Canada through the Canada Book Fund (CBF), Canada Council for the Arts, and the Province of British Columbia through the British Columbia Arts Council and the Book Publishing Tax Credit.

20 19 18 17 16 1 2 3 4 5

Printed in Canada